D0946842

THE ART COLLECTION *of*
UC DAVIS HEALTH SYSTEM

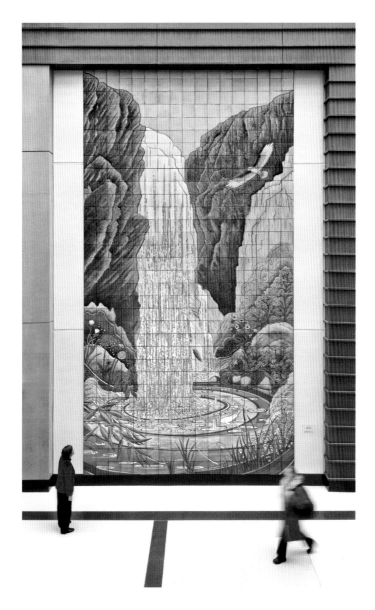

BY SUSAN J. WILLOUGHBY

University of California, Davis, Health System
Sacramento, California

Published by

Regents of the University of California

and UC Davis Health System

© 2012 Regents of the University of California

Designed by

Pat Grind Design

Photographs of artwork by

The artists

The photographers of UC Davis Health System

Donald Satterlee

Thomas Willoughby

Printed by

Fruitridge Printing

ISBN 978-0-9743072-9-9

Cover and title page:

Y O S H I O T A Y L O R
Resurgence 2010
handmade terra-cotta tiles with low relief carving
and fired underglaze finish; 32' x 17'

ART AND HEALING

LATE IN HIS CAREER, Albert Einstein observed that the "arts and sciences are branches of the same tree." UC Davis Health System shares this belief and has long recognized and promoted the nexus between art and healing. Through its art acquisition program, the health system has developed a collection that includes more than 2,000 pieces of original art by nearly 300 California artists.

Since it was established in 1983, the art collection has offered comfort, peace, and reflection. It has stimulated imagination and raised the human spirit. The collection has enriched the lives of the thousands of patients, families, faculty, students and staff who have seen it here – in waiting rooms, lobbies, corridors and other public spaces across our campus.

With the release of *The Art Collection of UC Davis Health System*, the opportunity is now available to all who appreciate the innate connection between art and healing to experience the oil paintings, watercolors, bronze sculptures, and terra-cotta tiles, that make up this exceptional collection.

ACKNOWLEDGEMENTS

IT HAS BEEN MY PRIVILEGE to shepherd the University of California, Davis, Health System art collection from its early beginnings to its current robust state. And of course I have had a lot of help along the way:

- from health system leaders who have supported the art program and encouraged its development

- from the team of dedicated individuals in the Department of Facilities, Design and Construction who attended to all the physical details of the program, from securing budgets to facilitating engineering on complex pieces

- from members of the Arts Advisory Committees, past and present, who have assisted in the selection of artists to be commissioned for new work

- and of course our deepest thanks to the artists themselves who have understood the change their artwork can bring to a healing and learning environment. Their works of art are a critical component of our commitment to compassionate care.

— S J W

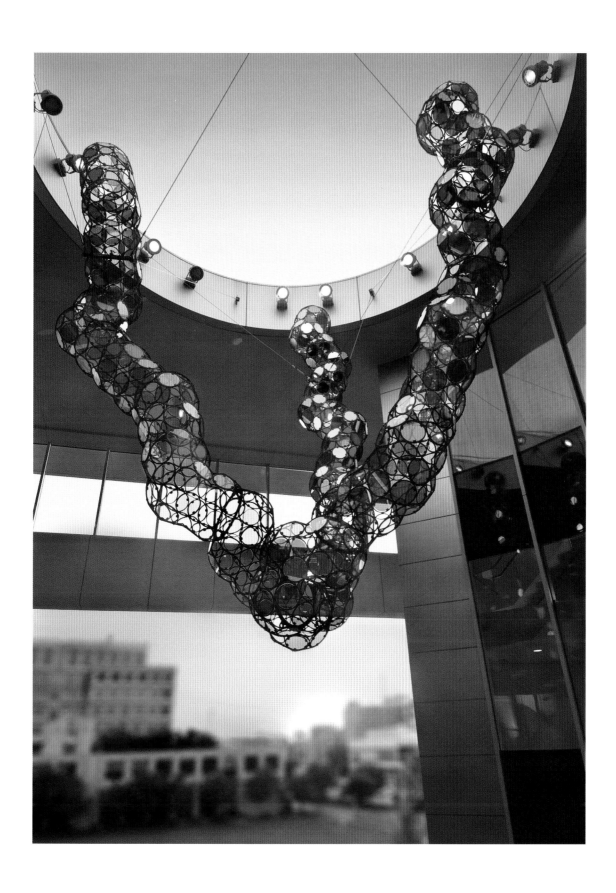

BEGINNING OF THE COLLECTION

ARTWORK HAS THE ABILITY to stimulate imagination and elevate the human spirit. And in an academic health environment, art has the power to promote serenity and encourage healing and learning. That is why UC Davis Health System has commissioned artwork for the public areas of its facilities. Its growing art collection was begun in 1983, as a critical component of the health system's commitment to provide patients with the most advanced medical technology available in an environment that was both welcoming and nurturing.

Because it was important for the public to feel welcomed the minute they walked through the front door, the first piece to be commissioned – a vitreous enamel mural by Sacramento artist Fred Uhl Ball – was installed in the lobby waiting area. The mural transformed the room; a change so immediately apparent and warmly received that new artworks were soon commissioned for other areas in the hospital most frequented by patients and their families. Art began appearing in elevator lobbies, corridors and consultation rooms, but nowhere was the transformation more welcome than in the Physical Medicine and Rehabilitation gymnasium, located in the basement of the hospital, where a wall-size mural by Stephanie Taylor visually expands the horizons of patients struggling to overcome disabling injuries.

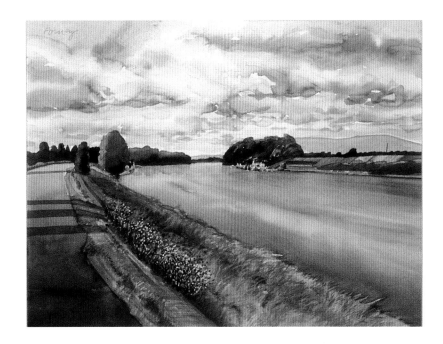

DARRELL FORNEY
Sacramento River 1983
watercolor; 15" x 20"

FRED UHL BALL
Arcadia 1983
vitreous enamel on copper; 45" x 163"

FRED UHL BALL
Untitled 1984
vitreous enamel on copper; 30" x 120"

AS THE ART PROGRAM progressed, and the collection began to take form, a set of selection guidelines was established. To create a visual expression of concern for the well-being of patients and their families, students and other members of the health system community, the artwork had to meet the following criteria:

■ reflect the superior quality of services provided by the health system, by the artwork itself being of high quality

■ support and build ties to the local visual arts community, by commissioning artwork from artists living in the geographic area served by the health system

■ help patients and their families cope with the uncertainties and intense emotions that accompany medical care, by employing designs and materials that are positive and reassuring

■ be durable, to withstand the wear and tear of public viewing

■ visually highlight the health system's inclusive environment, by collectively reflecting the artistic, cultural and ethnic diversity of our region

■ be affordable

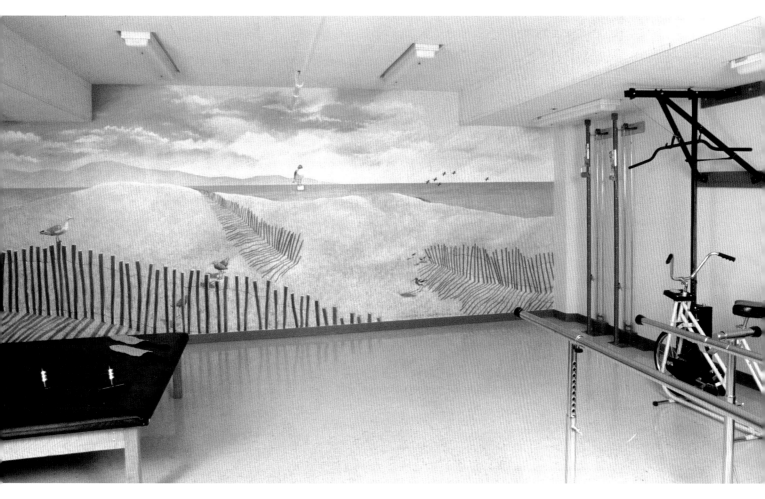

STEPHANIE TAYLOR
Untitled 1989
acrylic wall mural; 9' x 25'

Mural Detail

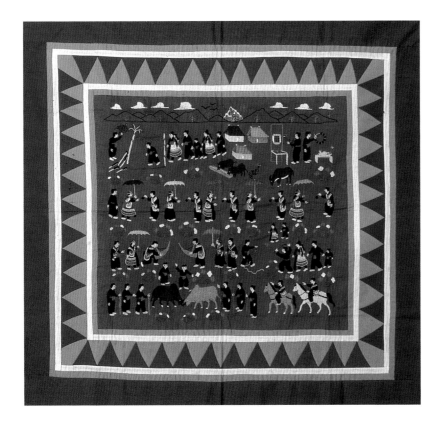

CHAMY THOR-LEE
Lunar Festival 1992
Pa Dao stitchery; 29" x 32"

A COMMITMENT WAS MADE to treat the artwork as a significant collection. Each piece is accompanied with a museum-quality label identifying the artist and is carefully inventoried. Biennial checks are made to ensure that all works are well-maintained. Because of this professional approach to the collection, artists have been more than generous in their creations. Understanding the impact their artwork can have in an environment where people are facing health challenges, the artists have been our partners in building this collection.

The collection has grown to include more than 2,000 original works of art in a variety of mediums – from black-and-white photographs to ceramic tile, from fiber to stainless steel. Together, the works encompass a full range of scale and form – from outdoor sculptures to small, intimate paintings. The artists themselves, as well as their works, reflect the rich diversity of our community.

FRANK LAPENA
Big Head Bole Dancer 1982
lithograph; 30" x 22"

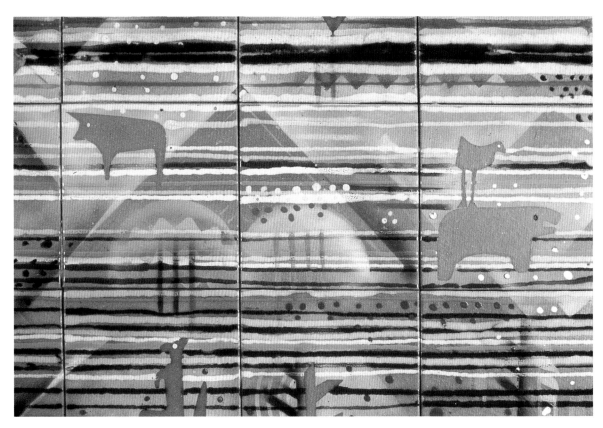

DONNA BILLICK
Detail from a 1983 glazed ceramic tile mural

BEGINNING OF THE COLLECTION

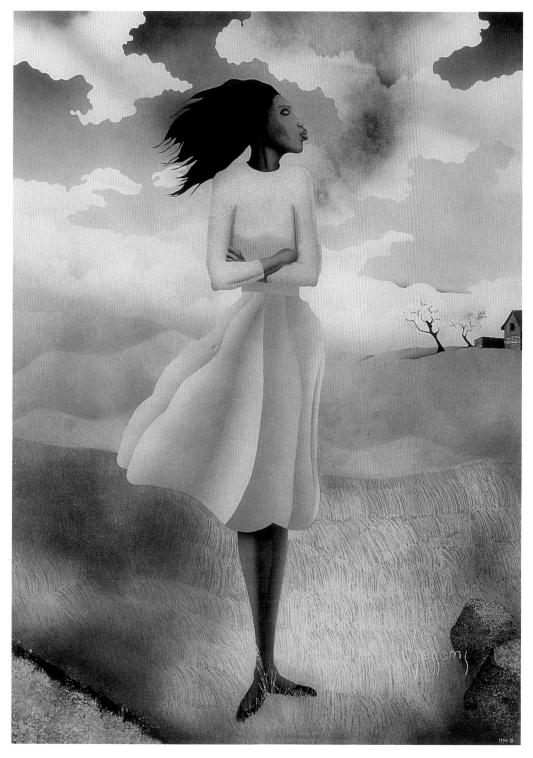

DEXTER SESSONS
Windy 1991
acrylic on glass; 27" x 21"

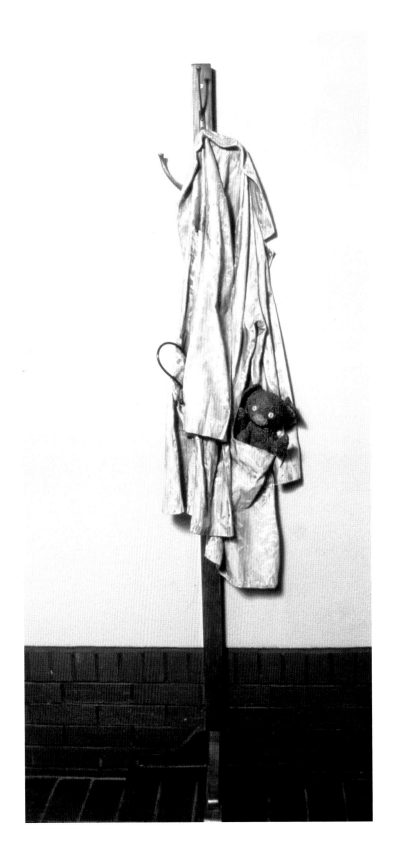

MARU HOEBER
Coat Tree 1993
bronze; 70" x 21" x 12"

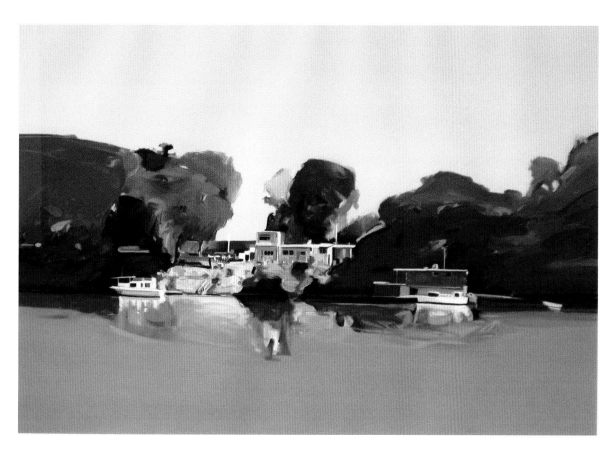

GREGORY KONDOS
River Landing 1996
lithograph; 26" x 38"

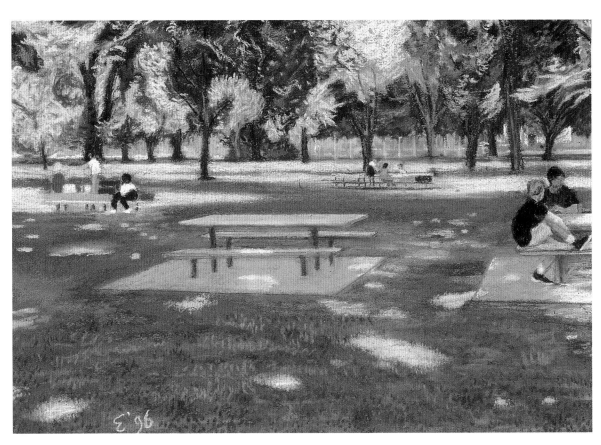

ROBERT ELSE
Picnic 1996
pastel; 12" x 16"

BEGINNING OF THE COLLECTION

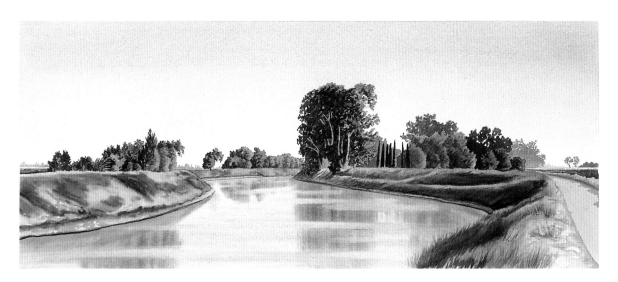

MARTY STANLEY
Early Morning Light 1989
watercolor; 22" x 48"

GIFTS TO THE COLLECTION

DARRELL FORNEY
Yes Landscape 1984
acrylic on canvas; 48" x 72"
Donated by the artist

MOST OF THE PIECES in this collection have been commissioned directly from artists, but several were the result of wonderful gifts. Sometimes it is a gift of artwork from an artist or his or her family; other times it comes from a collector or business that has relocated and can no longer display its art. And, once in awhile, it comes in the form of a donation of funds earmarked for the commissioning of new artwork.

STEPHANIE TAYLOR
Untitled 1998
acrylic on canvas; 24" x 29"
In Memory of Katherine Lufburro, by Her Friends

STEPHANIE TAYLOR
Untitled 1998
acrylic on canvas; 24" x 29"
In Memory of Sarah Heymann, by Her Friends

LEO KRIKORIAN
from a suite of lithographs
each 15" x 22"
Donated by the artist

20

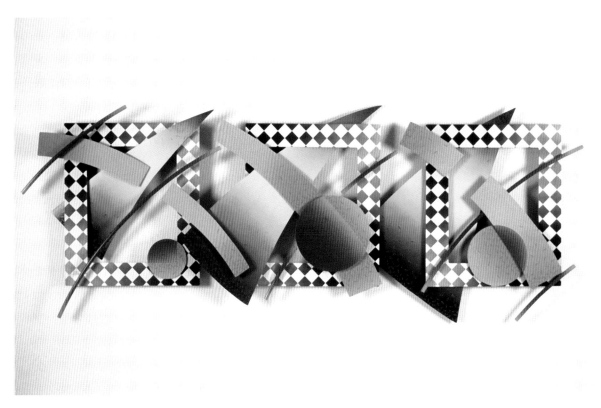

DAVID EWING
It's Never Enough 1988
steel, auto lacquer; 24" x 84" x 4"
Donated by Hyatt Regency Sacramento

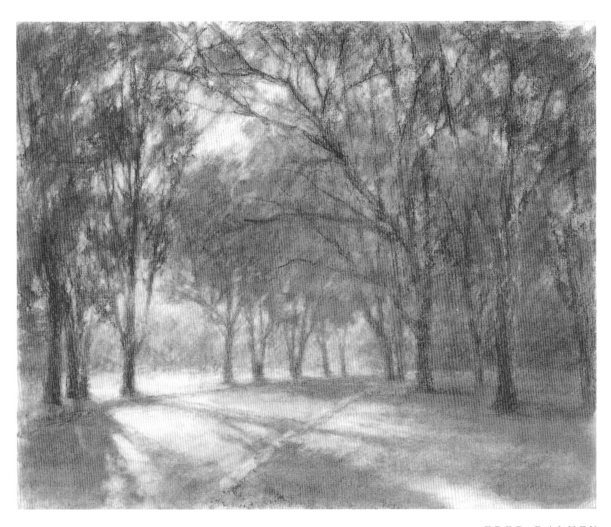

FRED DALKEY
William Land Park 1985
sanguine Conté on paper; 12" x 16"
Donated by the artist

EXPANDING THE COLLECTION

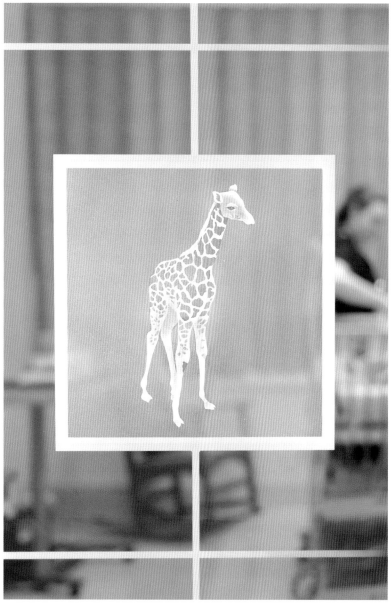

Detail from the *Animal Series*

AN EXPANSION of the hospital in 1998 opened new possibilities for artwork, such as the etched glass windows in the UC Davis Children's Hospital Neonatal Intensive Care Unit (NICU), and pieces for bold new waiting rooms.

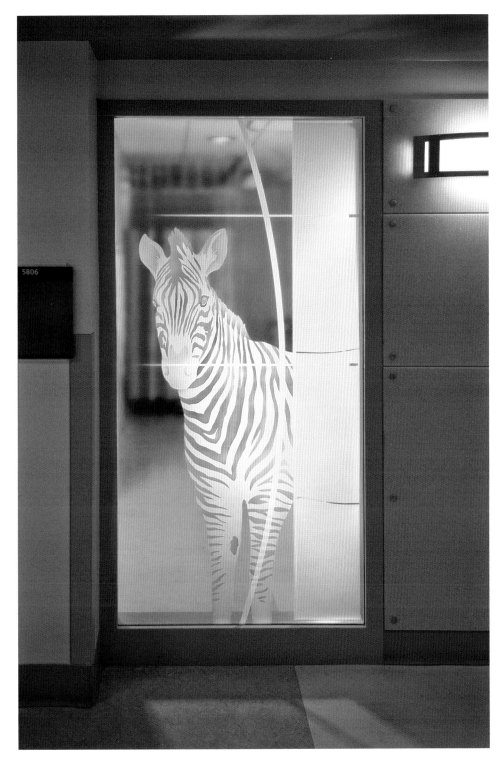

DAVID RIBLE
Animal Series 2005
sandblasted glass panels; 81" x 38"

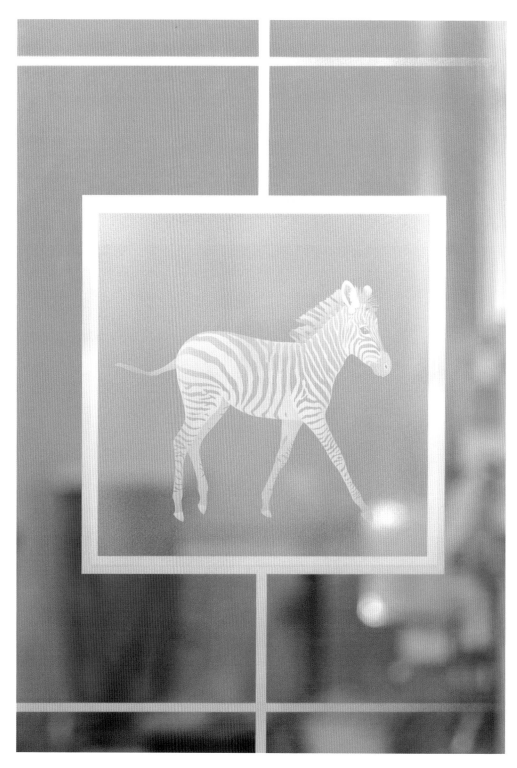

Detail from the *Animal Series*

EXPANDING THE COLLECTION

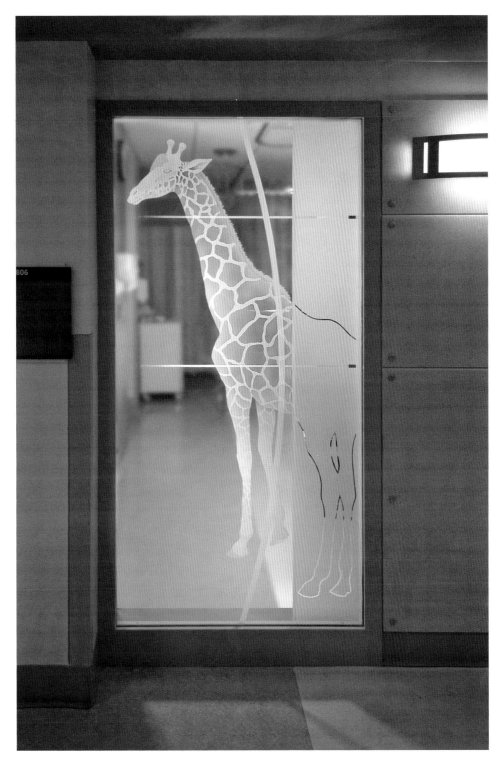

DAVID RIBLE
Animal Series 2005
sandblasted glass panels; 81" x 38"

KAREN FENLEY
Negotiating Access 2006
metal leaf, paint, sheet acrylic; 34" x 34"

MERLE SERLIN
Mustard Fields #2 1999
fabric; 22" x 30"

IMI LEHMBROCK-HIRSCHINGER
Sacramento Valley 1999
acrylic and oil pastel; each 28" x 39"

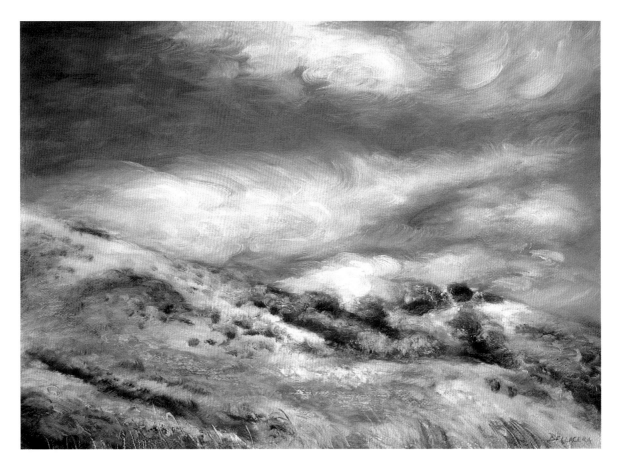

JOSEPH BELLACERA
Hillside #6 1999
oil on paper; 22" x 30"

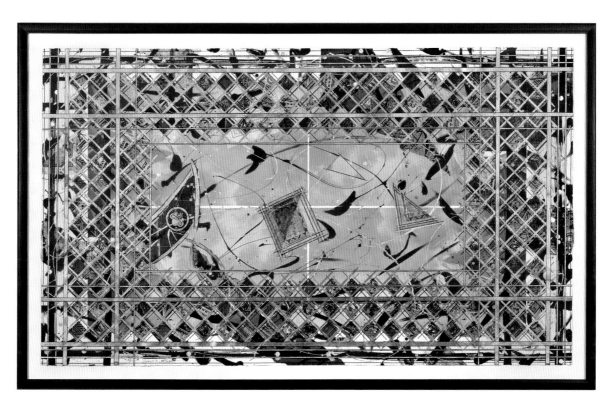

WILLIAM GATEWOOD
Skyscape 1991
mixed media collage; 42" x 73"
Donated by Moni Van Camp Kondos

THE MOST RECENT ADDITION to UC Davis Medical Center – the Surgery and Emergency Services Pavilion – opened in 2010. This wing includes the medical center's new front entrance, which opens onto a three-story-high atrium. To capitalize on this dramatic space, artist Yoshio Taylor was commissioned to create a 32-foot-high terra-cotta tile mural depicting a majestic waterfall. Surrounding the falls, hand-carved and -glazed tiles depict plants that have special medicinal value.

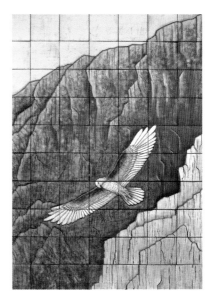

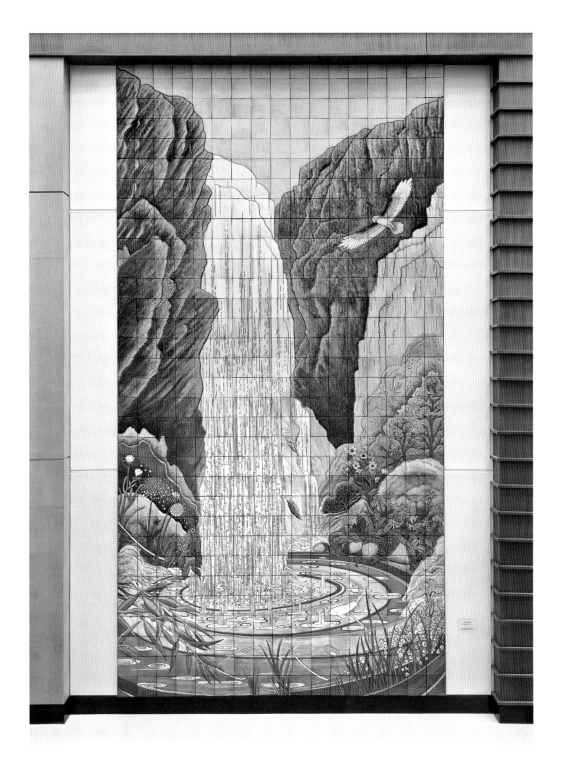

YOSHIO TAYLOR
Resurgence 2010
handmade terra-cotta tiles with low relief carving
and fired underglaze finish; 32' x 17'

MANUEL NUNES
Early Afternoon 2010
oil on paper; 16" x 30"

AND ONCE AGAIN, with this expansion, came an opportunity not only to commission new work from artists, but also to relocate work from other parts of the hospital no longer being used for patient care.

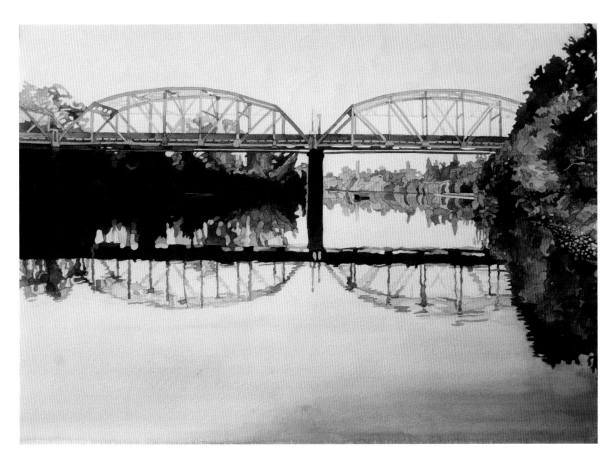

WILLIAM CHAMBERS
H Street Bridge 2010
watercolor; 22" x 30"

EXPANDING THE COLLECTION

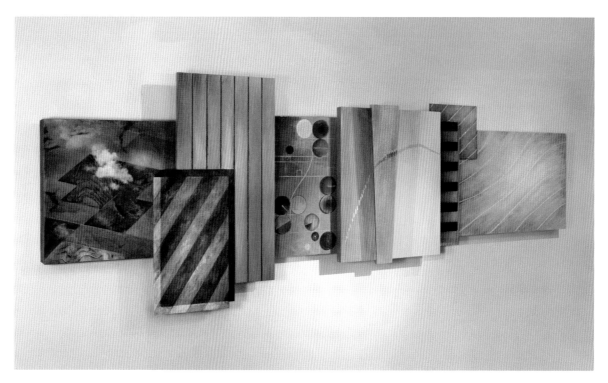

JOSEPH BELLACERA
Shifting Planes 2009
oil and acrylic on board; 32" x 96"

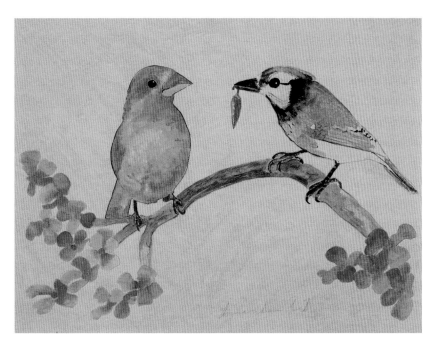

ARMANDO CID
Robin 2009
watercolor; 22" x 30"

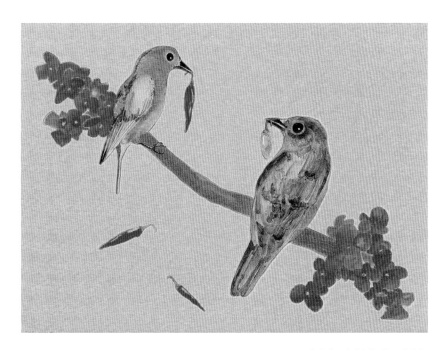

ARMANDO CID
Blue Jay with Chili 2009
watercolor; 22" x 30"

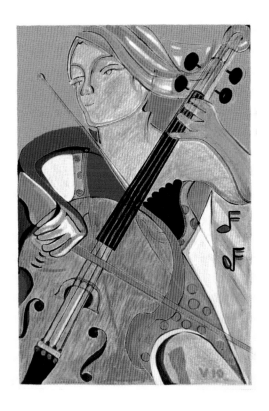

ESTEBAN VILLA
Christine Playing Cello 2010
acrylic on canvas; 30" x 24"

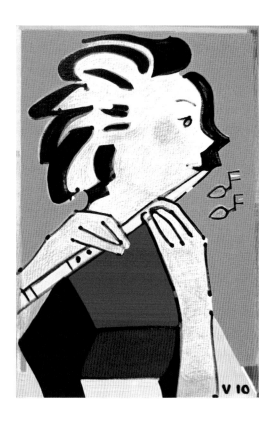

ESTEBAN VILLA
Flute Player Laurie 2010
acrylic on canvas; 30" x 24"

JOAN MOMENT
Tiddlywinks 2010
acrylic on paper; 22" x 30"

LEIGH VAN DER SCHYFF
Heron and Tortoise 2009
acrylic on paper; 26" x 40"

LEIGH VAN DER SCHYFF
New Paths and Old Ones 2009
acrylic on paper; 26" x 40"

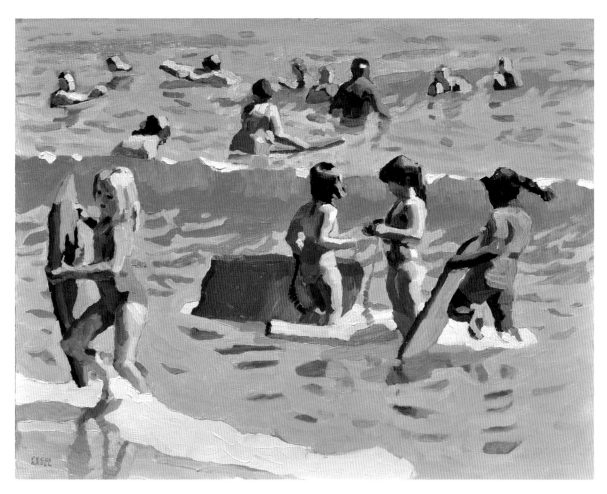

PEGGI KROLL-ROBERTS
Friends at the Beach 2010
oil on panel; 24" x 30"

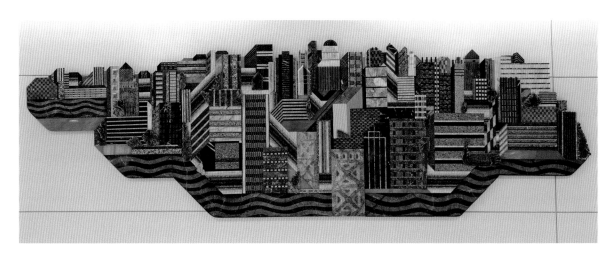

DONNA BILLICK
Sacramento Cityscape 1987
carved and faceted marble; 42" x 137"

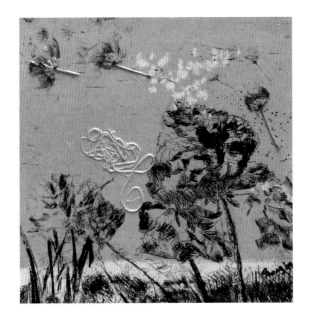

ALICE FONG
On the Road 2010
mixed media on panel; each 8" x 8"

43

A FOCUS ON CHILDREN

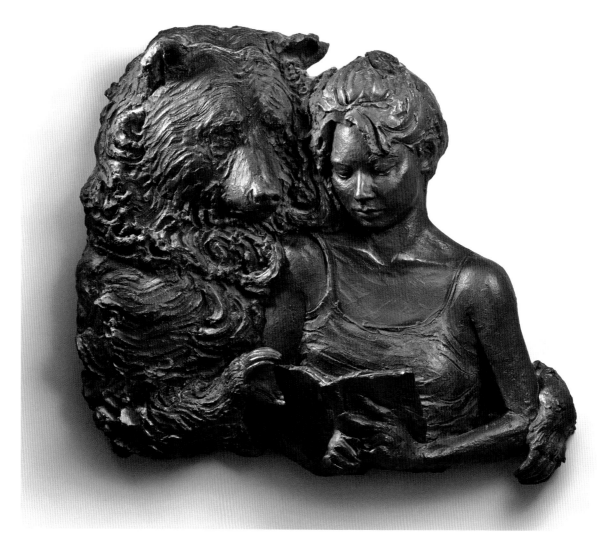

LISA REINERTSON
Bedtime Story 1992
bronze; 30" x 36" x 8"

UC DAVIS CHILDREN'S HOSPITAL, part of UC Davis Medical Center, offers children throughout inland Northern California the highest level of specialized pediatric care. Artwork is commissioned to be especially appealing to children and their families.

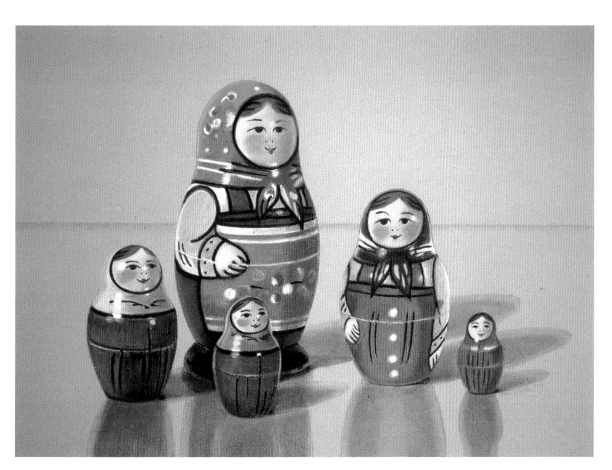

MARIA WINKLER
Matryoshka 1998
pastel; 22" x 30"

GERALD SIMPSON
Don't Burst My Bubbles 2010
acrylic and enamel pen; 24" x 36"

MICHAELE LECOMPTE
Tree of Life　1999
enamel on steel; 43" x 52"

STEPHANIE TAYLOR
Summertime 1993
acrylic on canvas; 32" x 42"

MAGGIE JIMENEZ
Bee Something Good 2010
fused glass; 16" x 16"

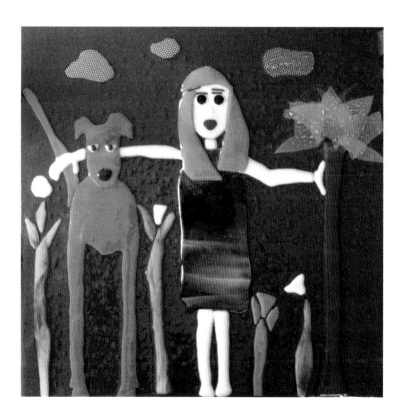

MAGGIE JIMENEZ
Cloudy Day 2010
fused glass; 16" x 16"

ARTWORK WHEREVER YOU GO

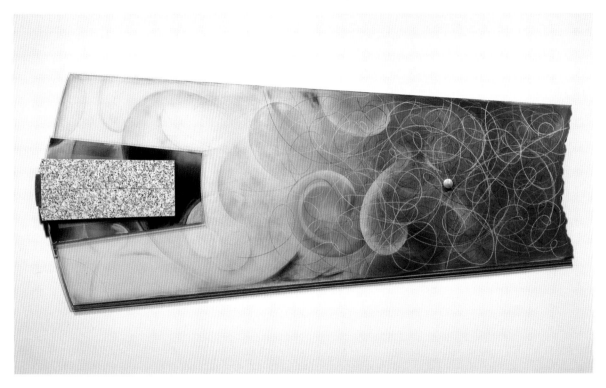

DAVID RIBLE
Untitled 1991
glass, paint, metal, granite; 26" x 84" x 2"

MANY OTHER BUILDINGS on the 142-acre
Sacramento campus and in the health sciences
district of the Davis campus feature artwork
on their walls. Students, and patients and
their families coming to the UC Davis Cancer
Center, for example, or to the Lawrence J.
Ellison Ambulatory Care Center, are quietly
greeted by artworks specifically chosen to
create pleasant and relaxing surroundings.

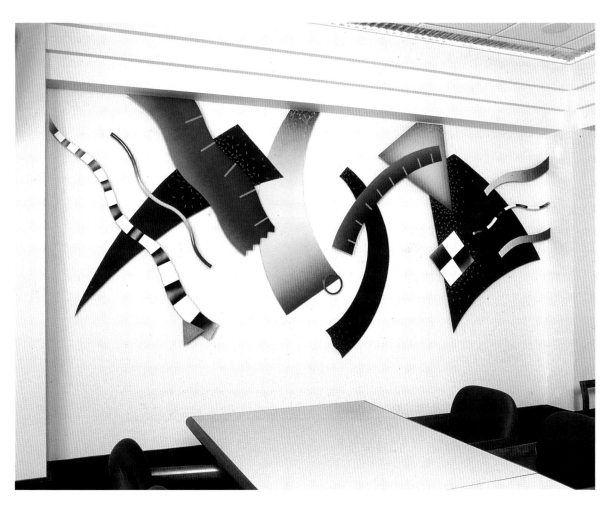

DAVID EWING
Hope 1991
welded steel and auto lacquer; 69" x 158"

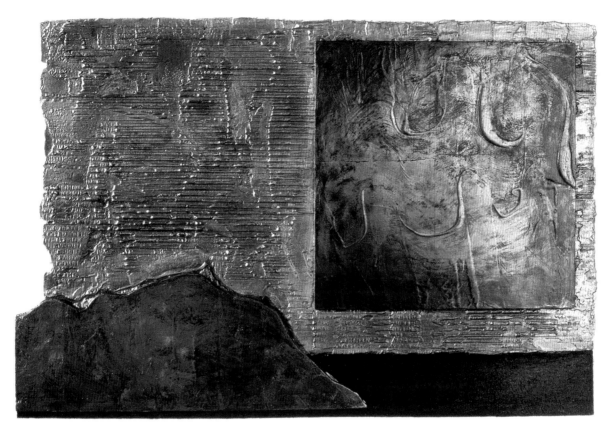

KAREN FENLEY
Grounded 2006
acrylic and metal leaf; 22" x 30"

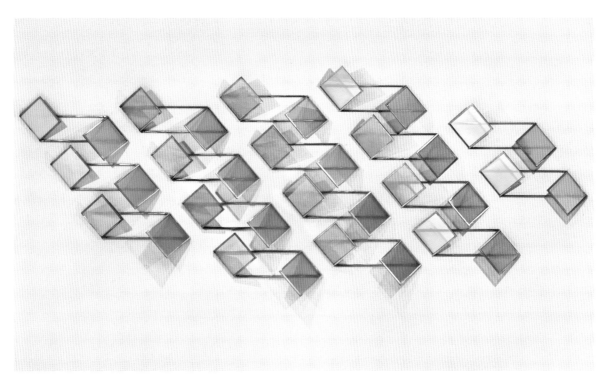

KURT RUNSTADLER
Origami 1998
dichroic glass; stainless steel; 52" x 134" x 4"

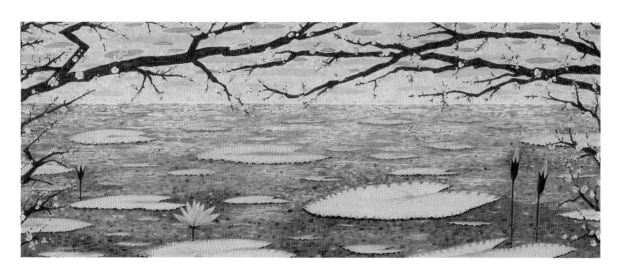

VICTORIA RIVERS
A New Morning 1994
pigment on fabric; 40" x 88"

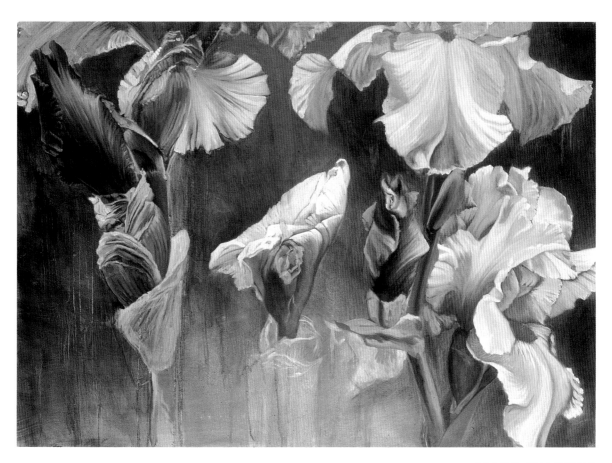

MARY WARNER
Iris Study 1995
oil on paper; 30" x 40"

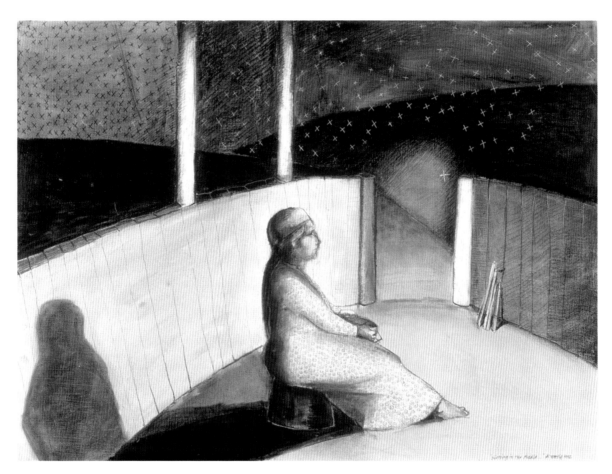

FRANK TUTTLE
Sitting in the Middle 1992
graphite, acrylic on paper; 22" x 29"

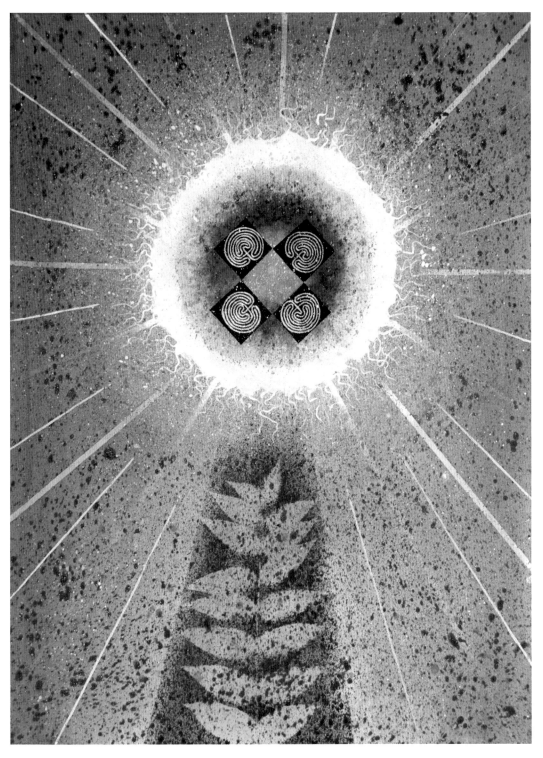

STAN PADILLA
Germination of Healing 2008
handmade mineral paints; 30" x 22"

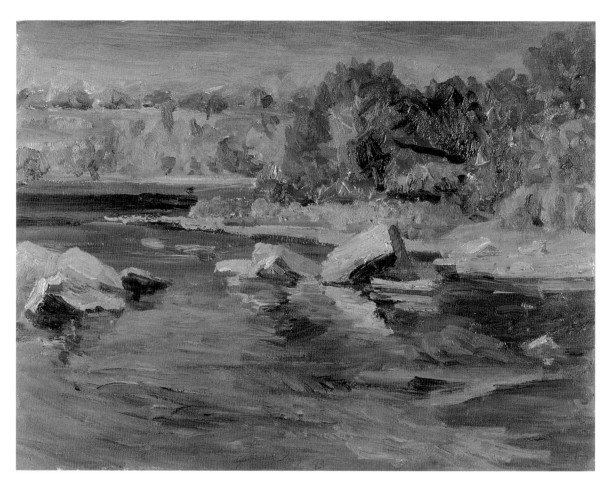

JIAN WANG
American River at Folsom 1993
oil on paper; 23" x 30"

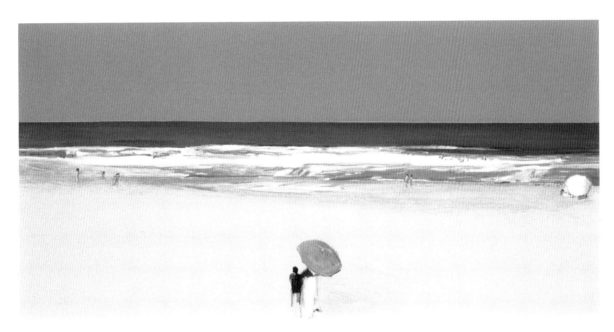

GREGORY KONDOS
A Retrospect 1993
lithograph; 16" x 28"

OUTDOOR SCULPTURES

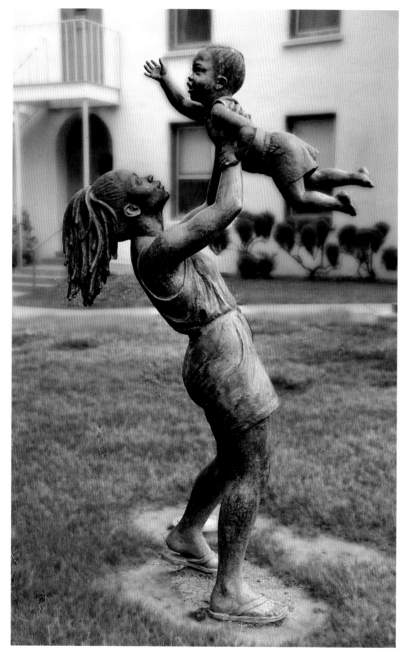

UC DAVIS HEALTH
SYSTEM'S impressive art
collection greets students,
health-care providers,
patients, families and
visitors before they set foot
inside. Outdoor sculptures
add to the welcoming
campus atmosphere and
enhance the landscape.

LISA REINERTSON
1993
bronze; lifesize

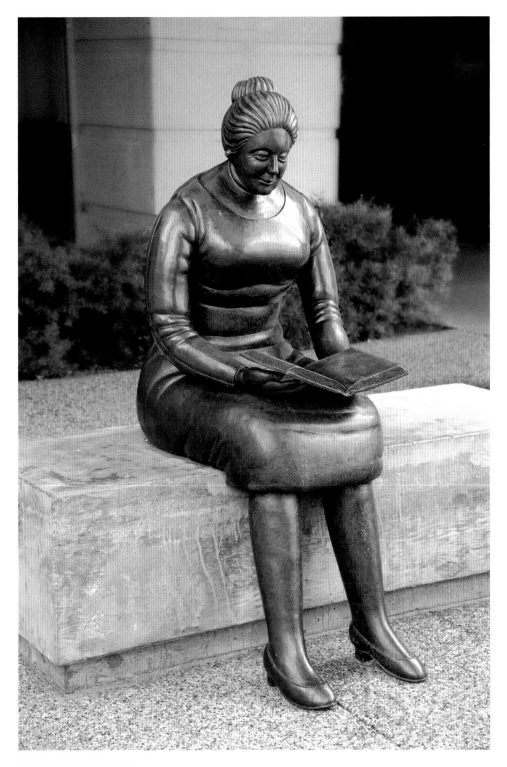

RUTH RIPPON
Waiting 1999
bronze; 59" x 22" x 39"

EXTENDING ART THROUGHOUT THE COMMUNITY

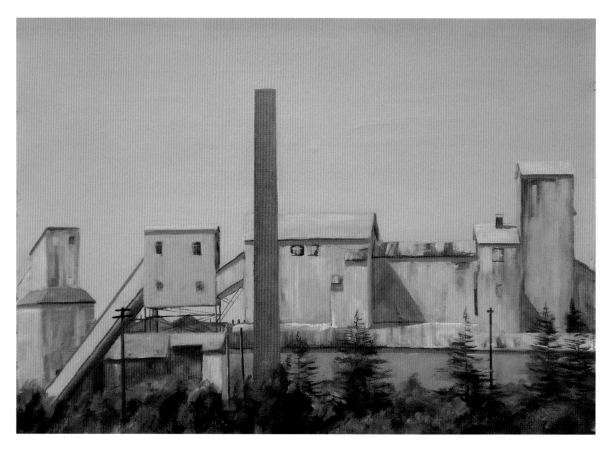

ANTHONY MONTANINO
Gladding McBean 2008
oil on paper; 20" x 28"

UC DAVIS HEALTH SYSTEM offers health
care throughout the Sacramento region, in 10
area communities. Every location has original
artwork; artists commissioned to create work
for these medical offices are often asked to
depict local landmarks, offering patients the
comfort of familiarity.

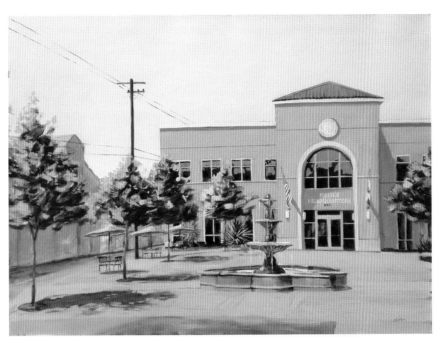

ANTHONY MONTANINO
Beerman's Plaza 2008
oil on paper; 20" x 28"

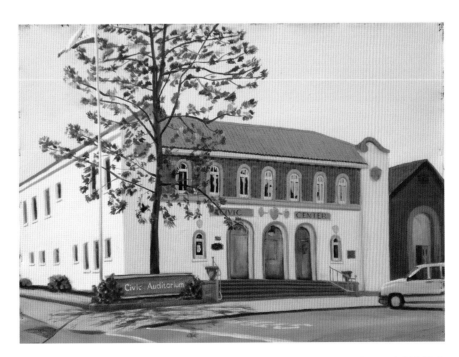

ANTHONY MONTANINO
Lincoln Civic Center 2008
oil on paper; 20" x 28"

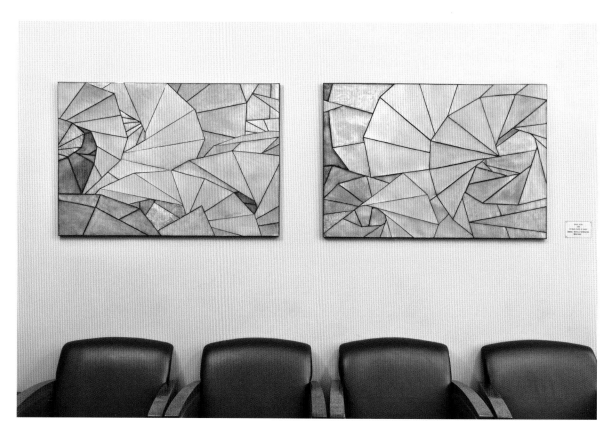

BRUCE BECK
Untitled 1998
vitreous enamel on copper; each piece 30" x 45"

EXTENDING ART THROUGHOUT THE COMMUNITY

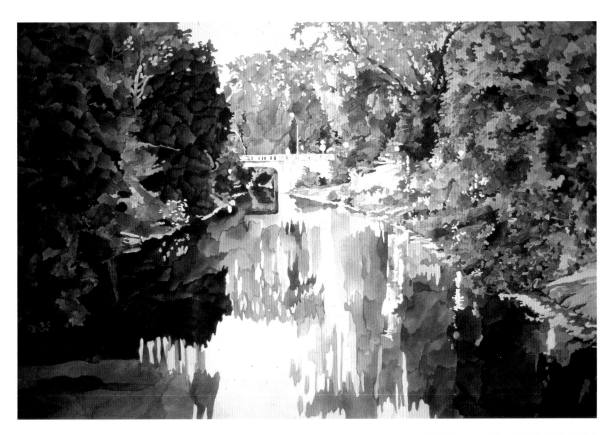

WILLIAM CHAMBERS
Putah Creek 1994
watercolor; 26" x 40"

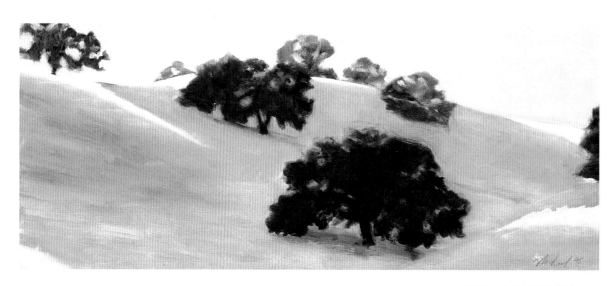

CHRIS NEWHARD
Blue Oak Savanna 1995
oil on board; 13" x 30"

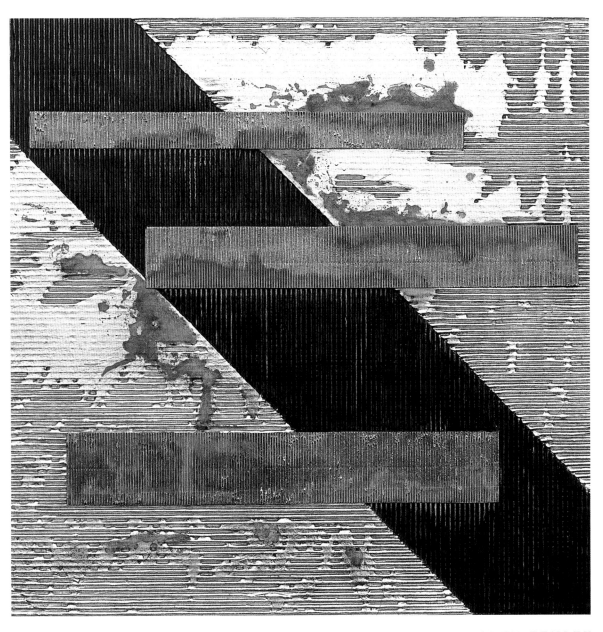

KAREN FENLEY
Bridges 2008
paint and metal leaf; 30" x 30"

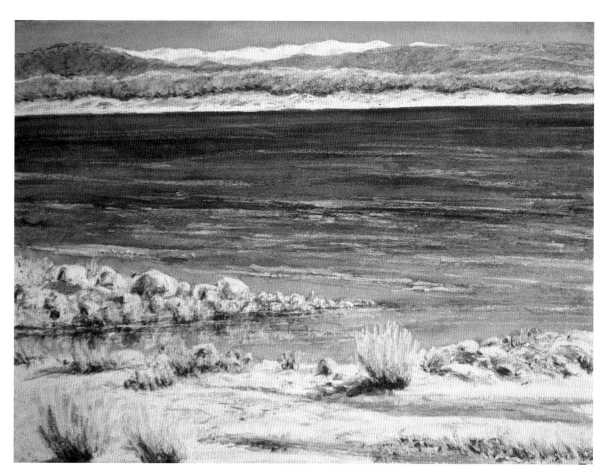

IMI LEHMBROCK-HIRSCHINGER
On a Clear Day at Folsom Lake 1998
watercolor, oil pastel; 22" x 30"

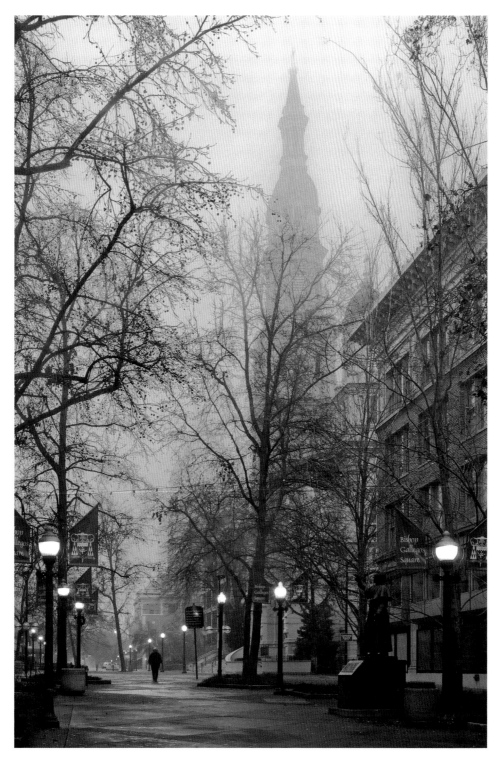

DONALD SATTERLEE
Cathedral Square 2010
split tone black-and-white print; 20" x 14"

SPECIAL COLLECTIONS

LARRY WELDEN
Randall Island Palms 1994
watercolor; 22" x 30"

OCCASIONALLY a special medical connection exists between an artist's work and a specific clinic or lab. When the Department of Physical Medicine and Rehabilitation wanted to commission artwork for the corridors outside its gym, it requested artwork developed by an artist who had a physical disability. Larry Welden, a Sacramento City College art instructor who walks with crutches, was selected. Likewise, the Department of Neurology and Neurological Disorders has several pieces by artists suffering from Alzheimer's disease. And the Department of Pathology selected Jan Louise's paintings on silk because it saw a similarity between her designs and what pathologists saw under the microscope.

EDITH H.
The Cow Jumped Under the Moon 1994
tempera; 15" x 22"
1994 Alzheimer's Gala – People's Choice Award

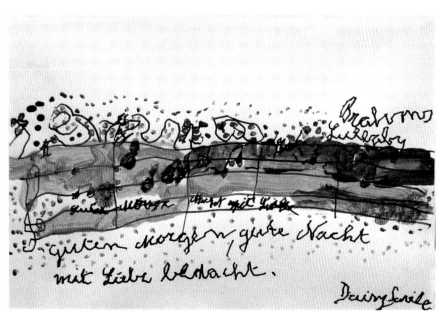

DAISY S.
Brahm's Lullaby 1995
tempera; 10" x 15"
Donated to the Alzheimer's Suite in memory of Margery Davis Warner

LARRY WELDEN
Farmhouse, Rosebud 1994
watercolor; 22" x 30"

JAN LOUISE
Bright Day 1999
permanent pigment on silk; 28" x 28"

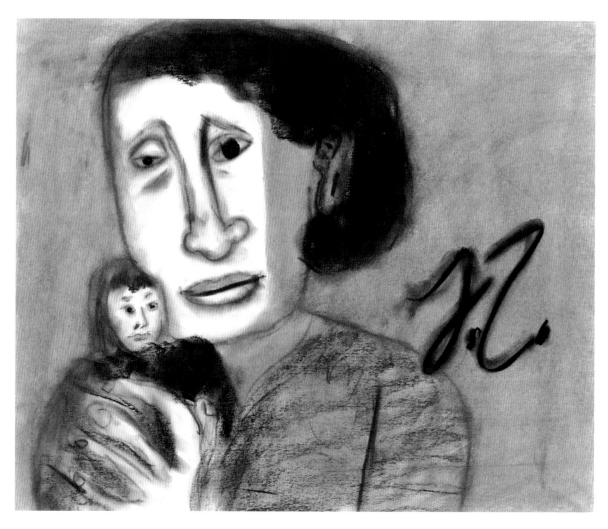

JONATHAN LERMAN
Untitled 2000
charcoal on Bristol board; 14" x 17"

A VERY SPECIAL TIE between artists and their disabilities exists at the UC Davis MIND Institute (Medical Investigation of Neurodevelopmental Disorders). In 1998, six visionary families, five who have sons with autism, helped found the institute, with the common goal of curing neurodevelopmental disorders. Plans to build a facility to house the new program were soon under way.

Knowing that UC Davis Health System had a significant art program, the founding families asked that artwork for the facility be created by artists who themselves had neurodevelopmental disorders. Two international art competitions were held, one for children and one for adults, resulting in the selection of 64 pieces by 38 artists. (A separate book, *Art of the MIND*, describes this collection).

CHRIS MURRAY
New York City – Manhattan 2001
acrylic, pencil, marker
on collaged paper; 53" x 24"

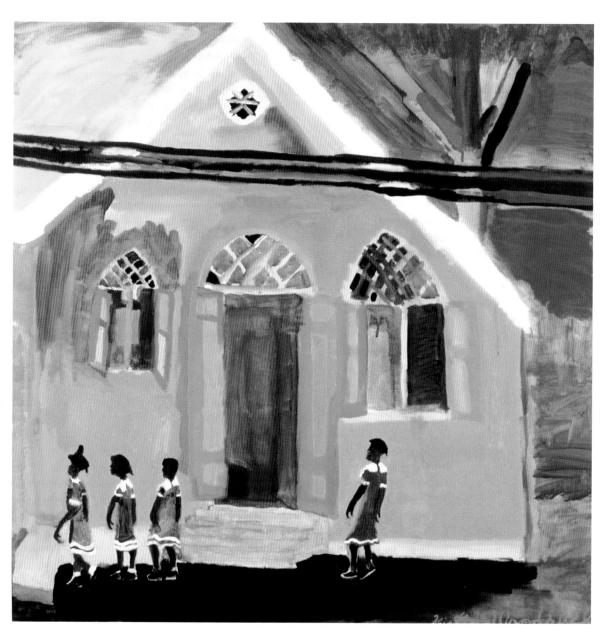

KRISTINA WOODRUFF
Pink Church
acrylic on canvas; 36" x 36"

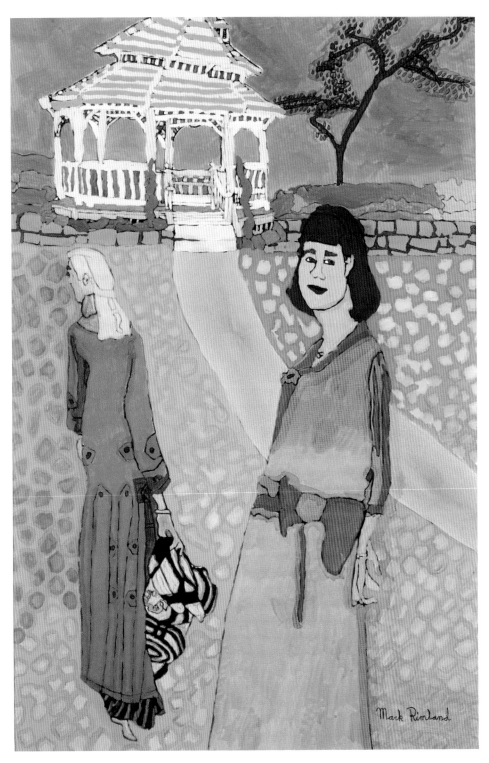

MARK RIMLAND
Gazebo 2000
acrylic on canvas; 36" x 24"

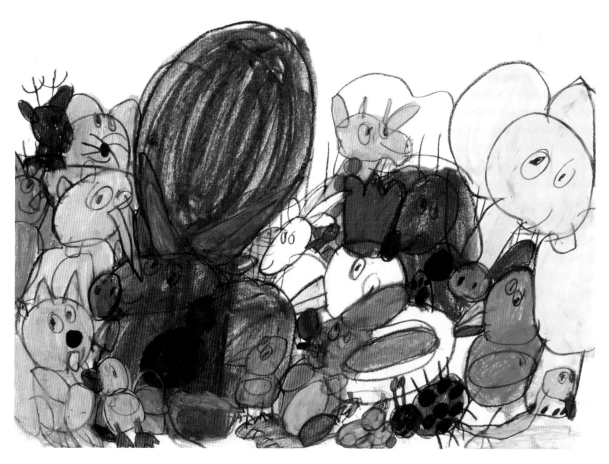

REED FESHBACK
The Zoo 2001
oil pastel; 18" x 24"

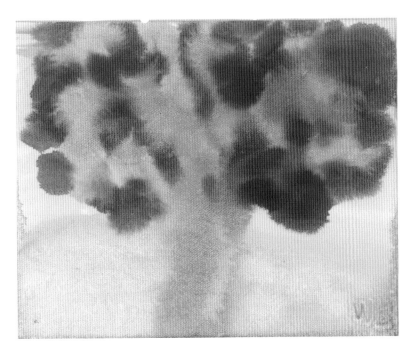

WILL BUCHER
Autumn 2000
watercolor; 9" x 11"

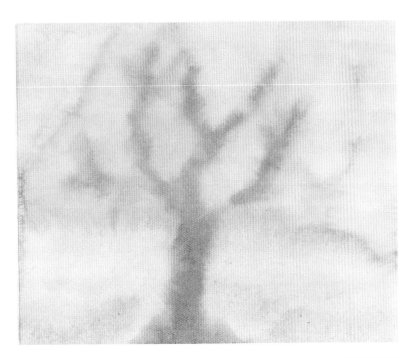

WILL BUCHER
Spring 2000
watercolor; 9" x 11"

SUPPORTING EDUCATION
THROUGH ART

KURT FISHBACK
Student Photo Essay 2008
black-and-white photographs;
each 20" x 16"

IN 2006, THE HUB of student learning moved from the university's Davis campus into a gleaming new four-story education facility located in the heart of the Sacramento campus. A photo essay documenting the addition of student life to the Sacramento campus was created by Sacramento photographer Kurt Fishback, and is displayed in the new Education Building.

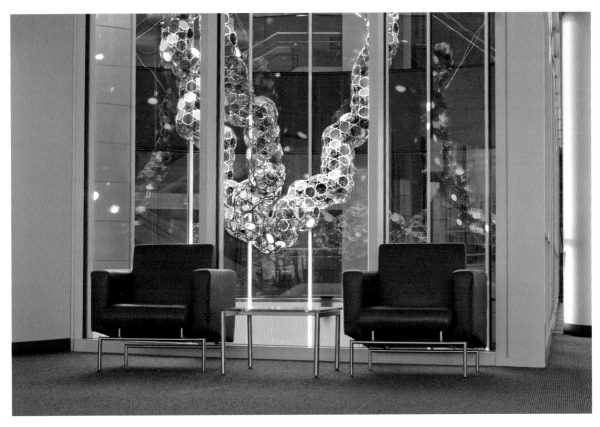

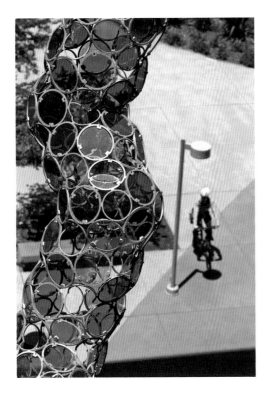

ROGER BERRY
Emergence 2011
dichroic glass and stainless steel
17'4" x 14'2" x 15'7"

ARTIST ROGER BERRY was commissioned to
create a dichroic glass and stainless steel sculpture
to be suspended between the two wings of the
Education Building on the Sacramento campus.
The sculpture highlights the innovative research
that is conducted at UC Davis Health System by
depicting the differentiation of totipotent stem cells
into pluripoptent cells as three columns of cells
flow from a center cluster.

82

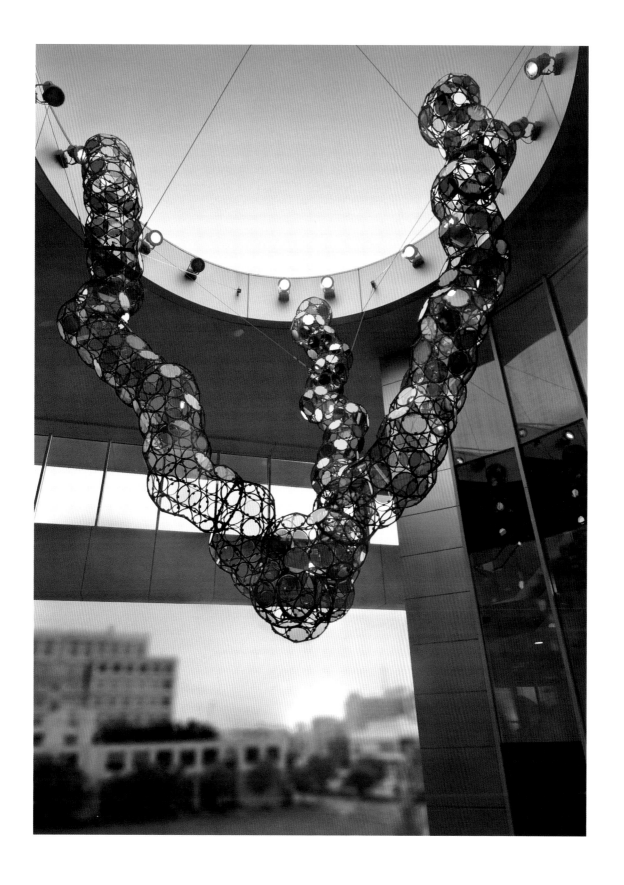

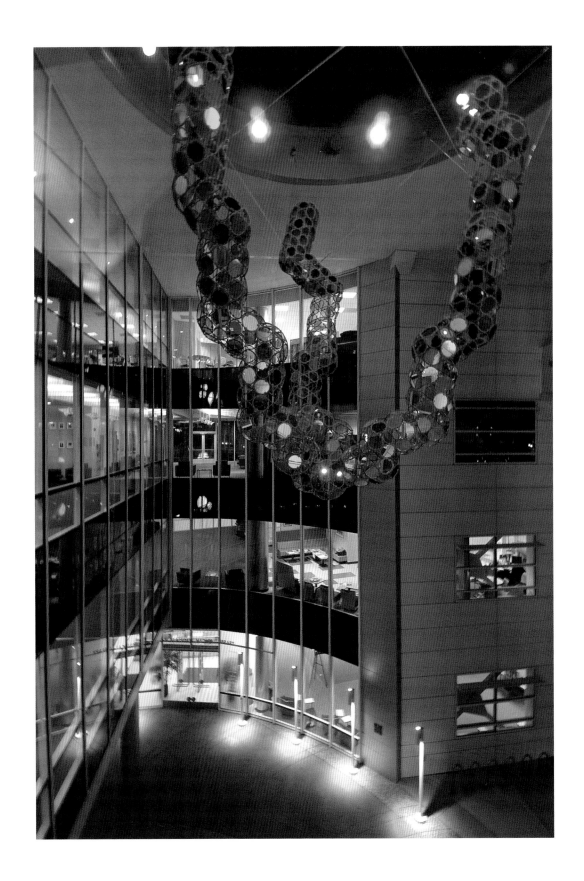

SUPPORTING EDUCATION THROUGH ART

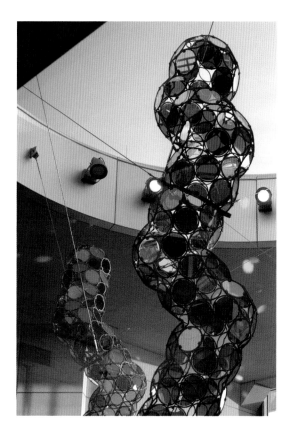

Emergence Details

MORE IMAGES FROM THE COLLECTION

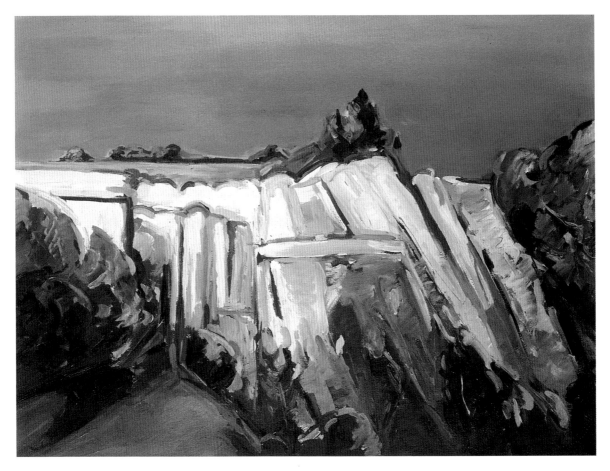

MATT BULT
Cliffs, Nevada City 1995
acrylic; 22" x 30"

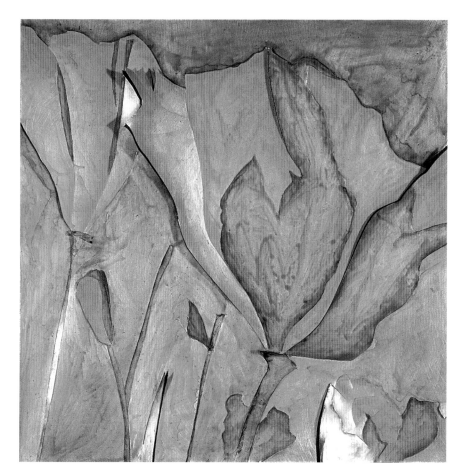

PATRICK MOONEY
Poppy 2008
acrylic and oil on metal; 20" x 20"

UC DAVIS HEALTH SYSTEM ART COLLECTION

MORE IMAGES FROM THE COLLECTION

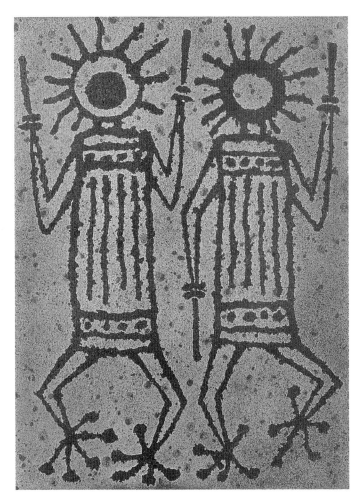

HARRY FONSECA
Earth Makers 1978
aquatint; 30" x 22"

MORE IMAGES FROM THE COLLECTION

PAT MAHONY
Monte Carlo – Three Windows 1990
watercolor, gouache; 22" x 42"

JANE MIKACICH
Giorni Ancora 1999
acrylic, beeswax, collage; 12" x 12"

MORE IMAGES FROM THE COLLECTION

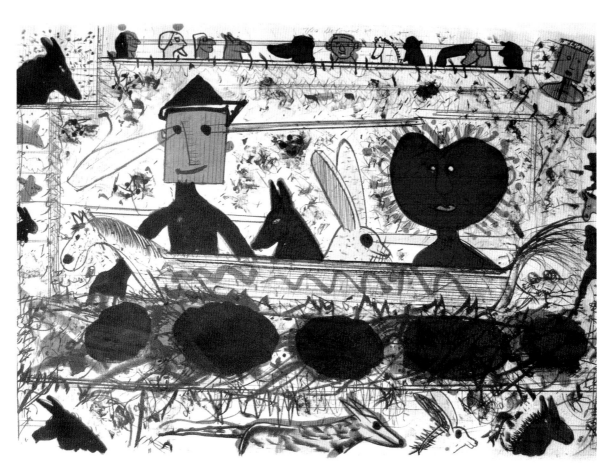

ROY DE FOREST
1980
lithograph; 22" x 30"
Private donation
Art © Estate of Roy De Forest
Licensed by VAGA, New York , NY

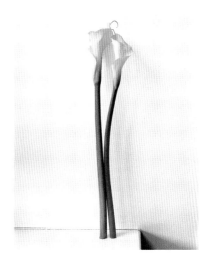

SYLVIA SENSIPER
Calla Lilies 2006
color photographs; each 32" x 25"

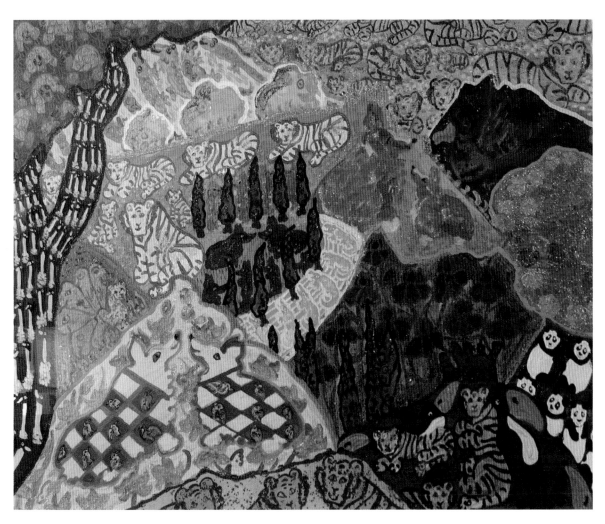

MAIJA PEEPLES-BRIGHT
Tiger Tuscany – Chukar Checkered Corgis 2004
acrylic, glitter; 22" x 30"

IT WILL CONTINUE

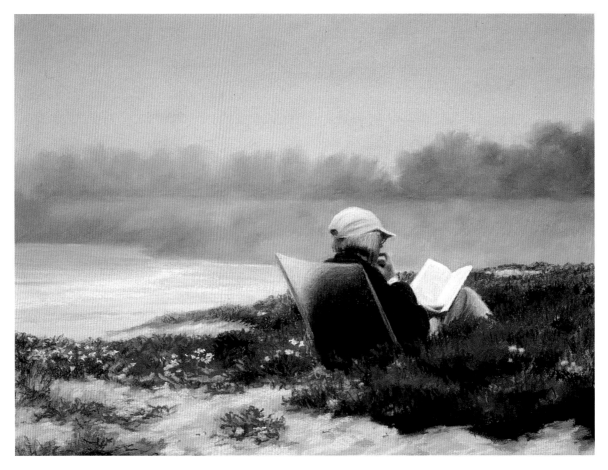

TERRY PAPPAS
A Good Book 1997
pastel; 22" x 30"

AS UC DAVIS HEALTH SYSTEM continues
to grow and meet the needs of the region, its
art collection will grow, and will continue to
be a critical part of the institution's commit-
ment to providing innovative education,
pioneering research and compassionate care
and to supporting the community it serves.

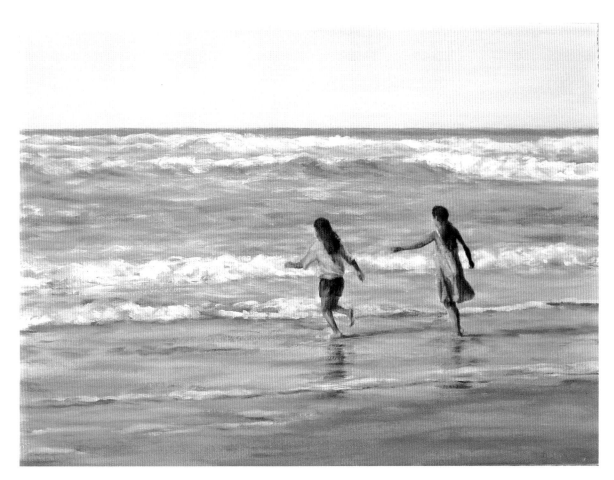

TERRY PAPPAS
Dillon Beach #2 2008
oil on paper; 22" x 30"

ARTISTS IN THE COLLECTION

Harry Curieux Adamson

Suzanne Adan

Jonathan Albers

Jim Alinder

Heidi Allen

Stuart Allen

Vernon Altree

Thomas Arie-Donch

Vicki Asp

Michael Azgour

Fred Uhl Ball

Thomas Barter

Bruce Beck

Hannah Behrendt

Joseph Bellacera

Roger Berry

Sarah Beserra

Donna Billick

Sharron Bliss

Joanne Blossom

Dane Bottino

Ann Ragland Bowns

Dr. James Brandt

David Braunsberg

Will Bucher

Matt Bult

Terry Busse

Kristine Anderson Bybee

Libby Caes

Kathy Carlisle

Sal Casa

William Chambers

Judith Chamow

Melissa Chandon

Cynthia Charters

My Chithor

Jennifer Christ

Douglas Chun

Armando Cid

Larry Clark

Lois Cohen

Mark Cohen

Micah Crandall-Bear

Sandi Cummings

Daisy S.

Fred Dalkey

Troy Dalton

John-Pierre David

Alonzo Davis

Roy De Forest

Judy Decker

Sandy Delehanty

Margot Didier

Tom Dochterman

Kathy Donaldson

Eileen Downes

Anne Duncan

Pan Duong

DIANE POINSKI
Soft Light 2009
hand-colored photograph; 16" x 20"

GREGORY KONDOS
River Edge 1998
lithograph; 18" x 40"

Brenden Eddie

Lynn Eder

Edith H.

Marilyn Eger

Robert Else

Mark Emerson

Marion Epting

Noah Erenberg

Alex Escalante

Genevieve Espinoza

David Ewing

Peig Fairbrook

Karen Fenley

Reed Feshbach

Tyler Fihe

Kurt Fishback

Peter Flaum

Gioia Fonda

Alice Fong

Harry Fonseca

Darrell Forney

Helen Frankenthaler

Jean Gallagher

Jeremy Michael Gallen

William Gatewood

Alexis Genung

Mary Glasson

Luis Gonzales

Arthur Gonzalez

Maya Christina Gonzalez

Phil Gross

Ricky Hagedorn

Marilyn Halevi

Frankie Hansbearry

Linda Hanson

Thomas Harris

Wynne Hayakawa

Rudy Haynal

Shirley Hazlett

Kevin Hellon

STAN PADILLA
Earth: Healer of the Body 2009
mixed media on paper; 30" x 22"

FRANKIE HANSBEARRY
Glauca Plant 1997
watercolor; 22" x 30"

Caryl Henry

Miles Hermann

Julie Hirota

James Hirschinger

Maru Hoeber

Alfred E. Holland

Jack Hooper

Peggy Hooper

Jeri Janis

Helen Jewel

Maggie Jimenez

Joseph Johns

Holley Junker

Blanche Kawahara

Susan Keizer

Gene Kennedy

Judy Kennedy

Robert Kirschner

Gregory Kondos

Richard Koski

Wosene Kosrof

Leo Krikorian

Peggi Kroll-Roberts

James Kuiper

Bill Kuyper

Laureen Landau

Helen Landgraf

Frank LaPena

Dixie Laws

Bruce Leavitt

Michaele LeCompte

May Lee

Me Lee

Yer Lee

Allison Lefcort

Imi Lehmbrock-Hirschinger

Jonathan Lerman

Barbara Leventhal-Stern

Peter Wayne Lewis

Gina Leyton

Joanne Lindeman

Cal Ling

David Lobenberg

Yeng Lor

Jose Lott

Brenda Louie

Jan Louise

Diane Lumiere

Gregory A. Lynn

Laura Mah

Merrill Mahaffey

Pat Mahony

Colleen Maloney

Matteson

Joan Mayberry

Patricia Tool McHugh

Phillip McMurray

Ryan McMurray

Franco Mendoza

Jane Mikacich

Patris Miller

Lisa Milo

Jeanne Moje

Joan Moment

Thomas Monaghan

Anthony Montanino

Patrick Mooney

Barbara Moran

Rick Morrison

See Moua

Richard Murai

Chris Murray

Rudi Nadler

Janice Nakashima

Tomye Neal-Madison

Chris Newhard

Jeff Nichols

Jack Nielsen

Bruce Nixon

Patricia North

Manuel Nunes

E.Z. O'Connell

Juanishi V. Orosco

Robert Ortbal

Stan Padilla

Ann Dobson Palmer

Terry Pappas

Michael Pease

Ron Pecchenino

Maija Peeples-Bright

Roland Petersen

William S. Phillips

Christophe Pillault

Christopher Platt

Kathleen Plummer

Diane Poinski

Ric Preston

Gary Pruner

Carolyn Quinn-Hensley

Kerri Quirk

Barbara Rainforth

J.P. Redman

Lisa Reinertson

David Rible

Nina Riddle

Mark Rimland

Ruth Rippon

Victoria Rivers

Marie-Louise Rouff

Jennifer Roussin

LISA WINLOCK
Afternoon Tea 2008
fabric, brass buttons; 27" x 16"

Criag Ruhe

Kurt Runstadler

Gretchen Ryan

Elizabeth Saltos

Joshue Wayne Samuels

Susan Sarback

Donald Satterlee

Harold Schwarm

Joseph-Nicholas Sciortino

Sylvia Sensiper

Merle Serlin

Paul Sershon

Dexter Sessons

Short Center South

Jerald Silva

Gerald Simpson

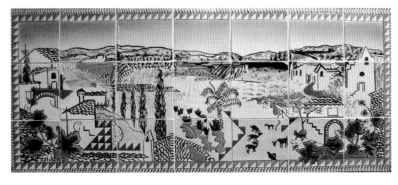

DONNA BILLICK
España 1993
handmade tile, glaze; 25" x 57"

Nico Smith

Mel Smothers

James Snidle

Randy Snook

Steve Solinsky

Elizabeth Solomon

Carol Spain

Mitsuyo St. Klair

James R. Stabenau

Andrew Stamm

Marty Stanley

Roger Stephens

Monica Stewart

Lynda Stegall

Sachiko Sugawara

George Sumner

Yana Takahashi

Ralph E. Talbert

Stephanie Taylor

Yoshio Taylor

Carolynn Thomason

Chamy Thor-Lee

Leslie Toms

Michael Torrice

Philip Travers

Francis Tsonetokoy

Rakusan Tsuchiya

Sheyne Tuffery

Frank Tuttle

Leigh Van Der Schyff

Ellen Van Fleet

Stacy Vetter

Esteban Villa

Kyle Walsh

Jian Wang

Mary Warner

Lois Warren

Kazuko Watanabe

MARIA WINKLER
Just Ducky 2000
pastel; 22" x 30"

Richard Wawro

Andrea Way

Larry Welden

Margaret Welty

Paula Wenzl-Bellacera

Gina Werfel

George Widener

Steven Wiget

Marcelle Wiggins

David Wiley

Janet Williams

Maria Winkler

Lisa Winlock

Laurie Winthers

Eleanor Wood

Kristina Woodruff

Kou Xiong

Xu Yang

Larry Young

Wei Ke Yu

Barbara Zook

Several unknown artists

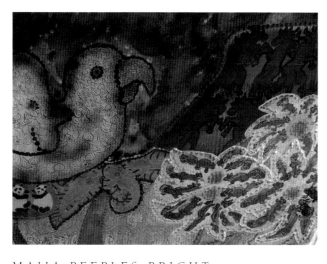

MAIJA PEEPLES-BRIGHT
A Parrotdox Too 1988
watercolor and oil; 22" x 30"

The Art Program of the University of
California, Davis, Health System
is administered by the Facilities, Design
and Construction Department.

A special committee advises on the
selection of artists and other related
art activities.